This book is a culmination of sketches from 1997 to present day. I have a lot of books setting on my shelves rotting away, why not put them into something presentable. My first book was started when I worked as a watch repairman, needless to say I had a lot of time to kill. I have kept a sketchbook consistently since then. Enjoy!!

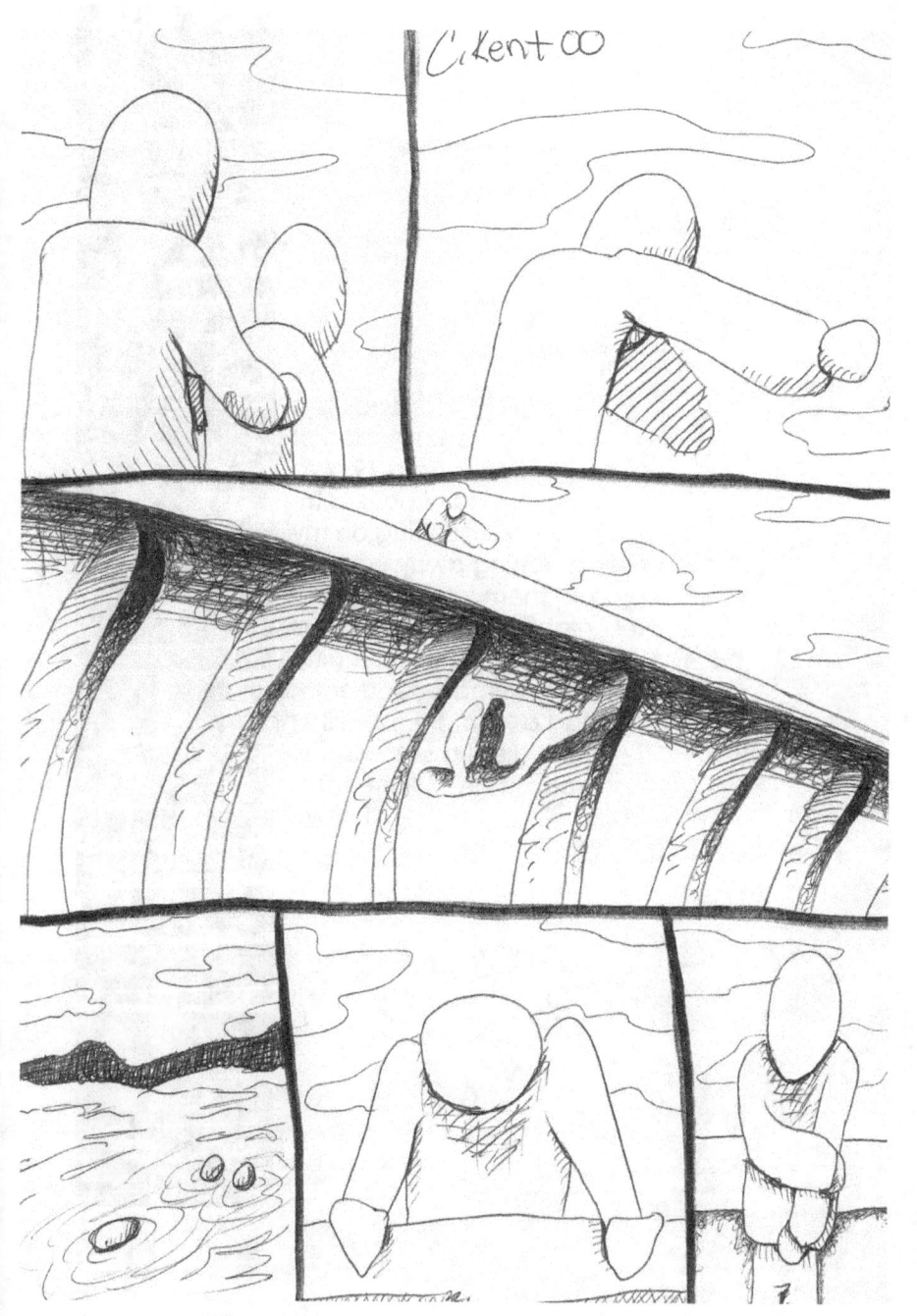

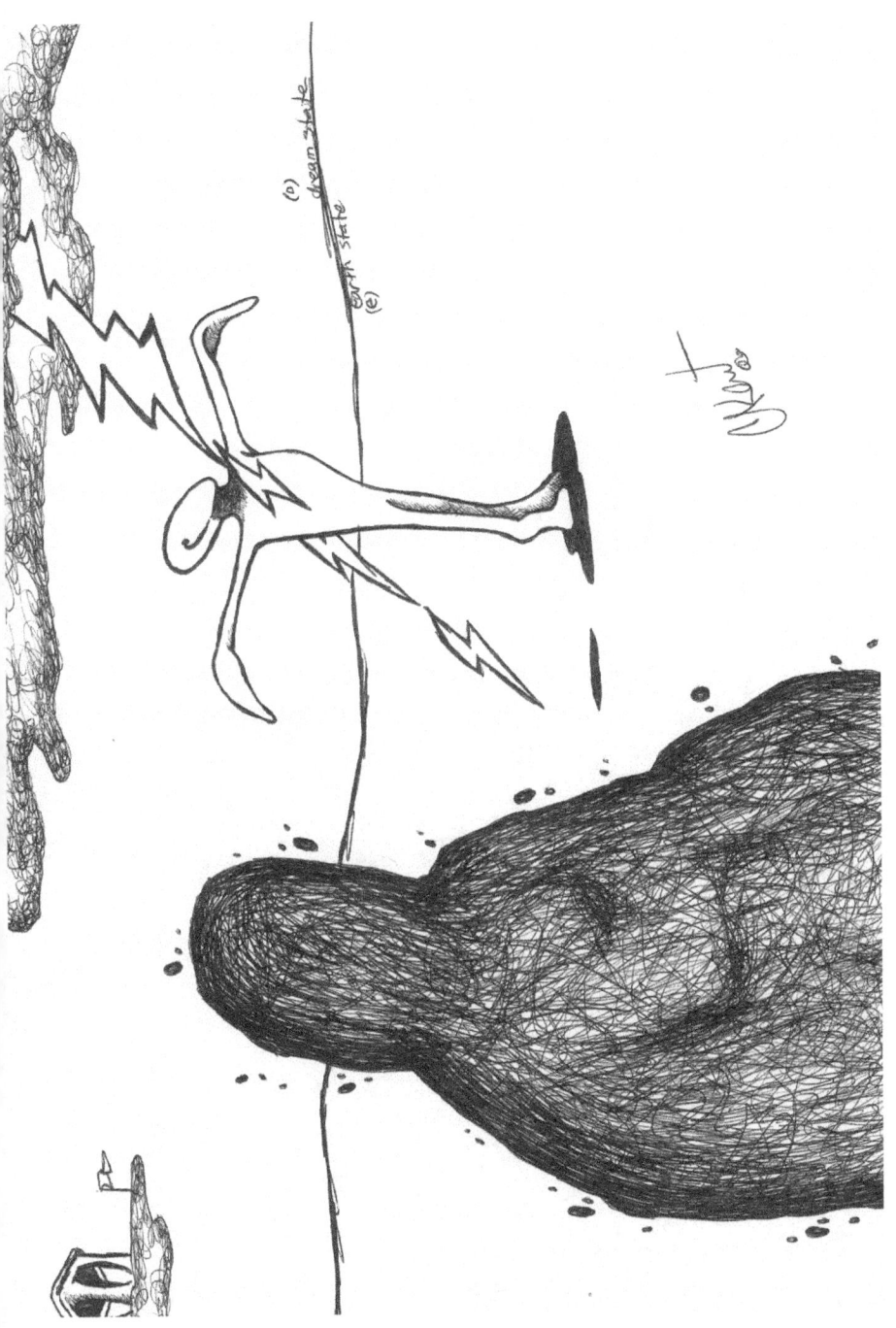

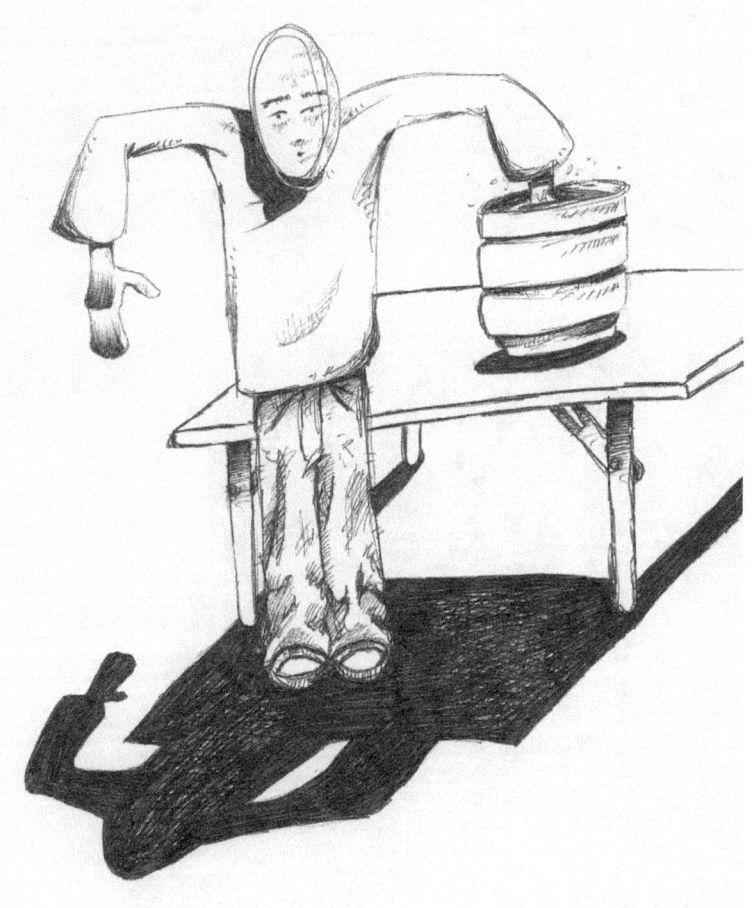

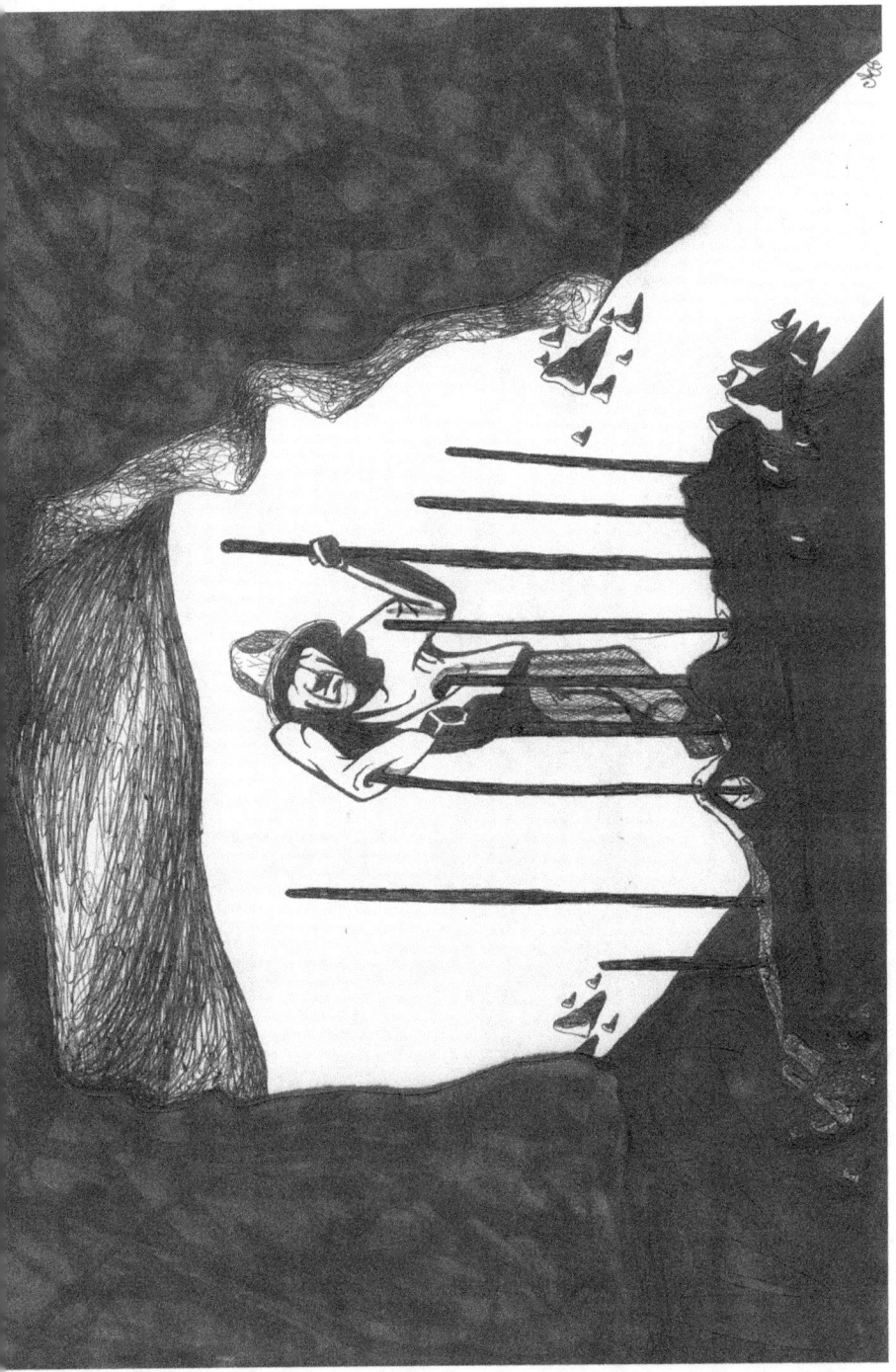

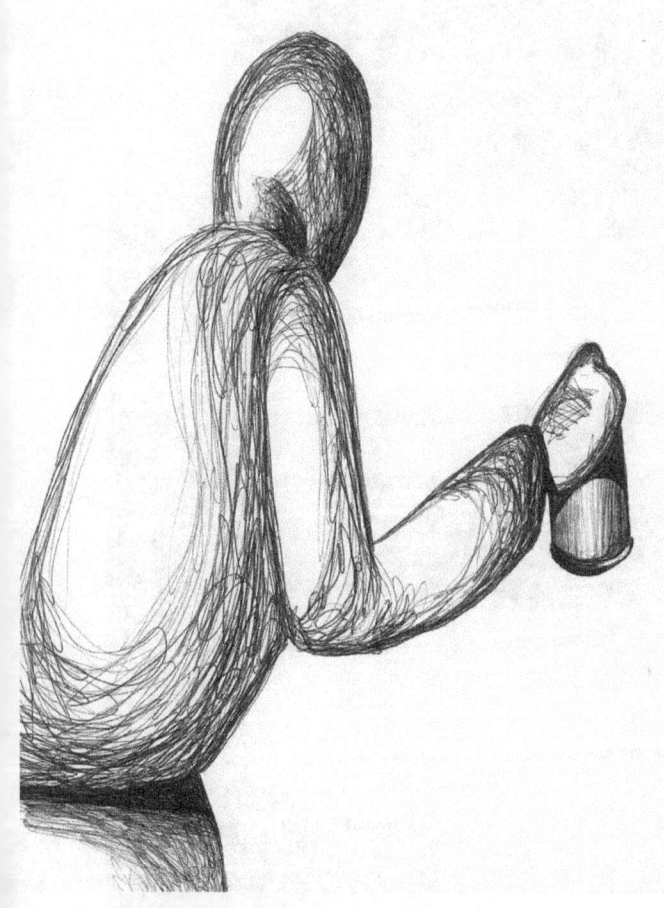

TAemanshioneAT

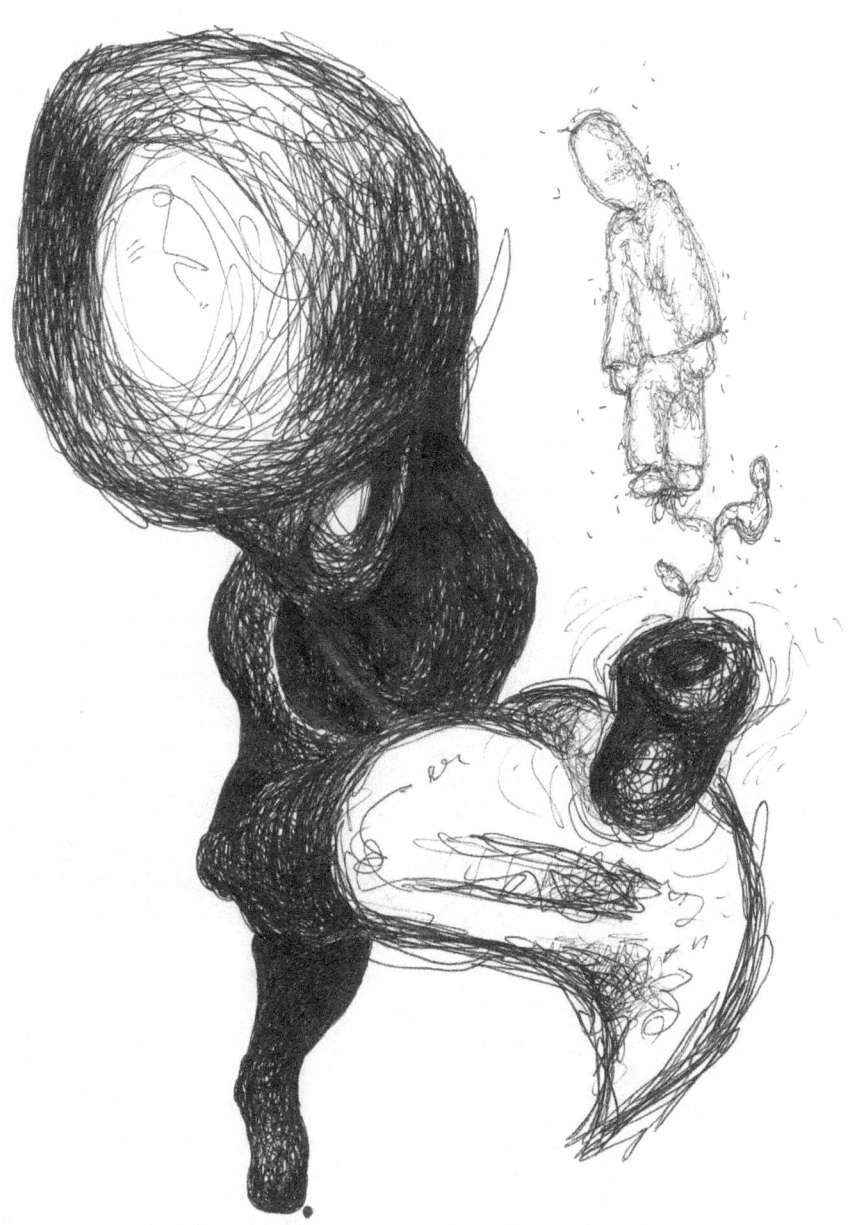

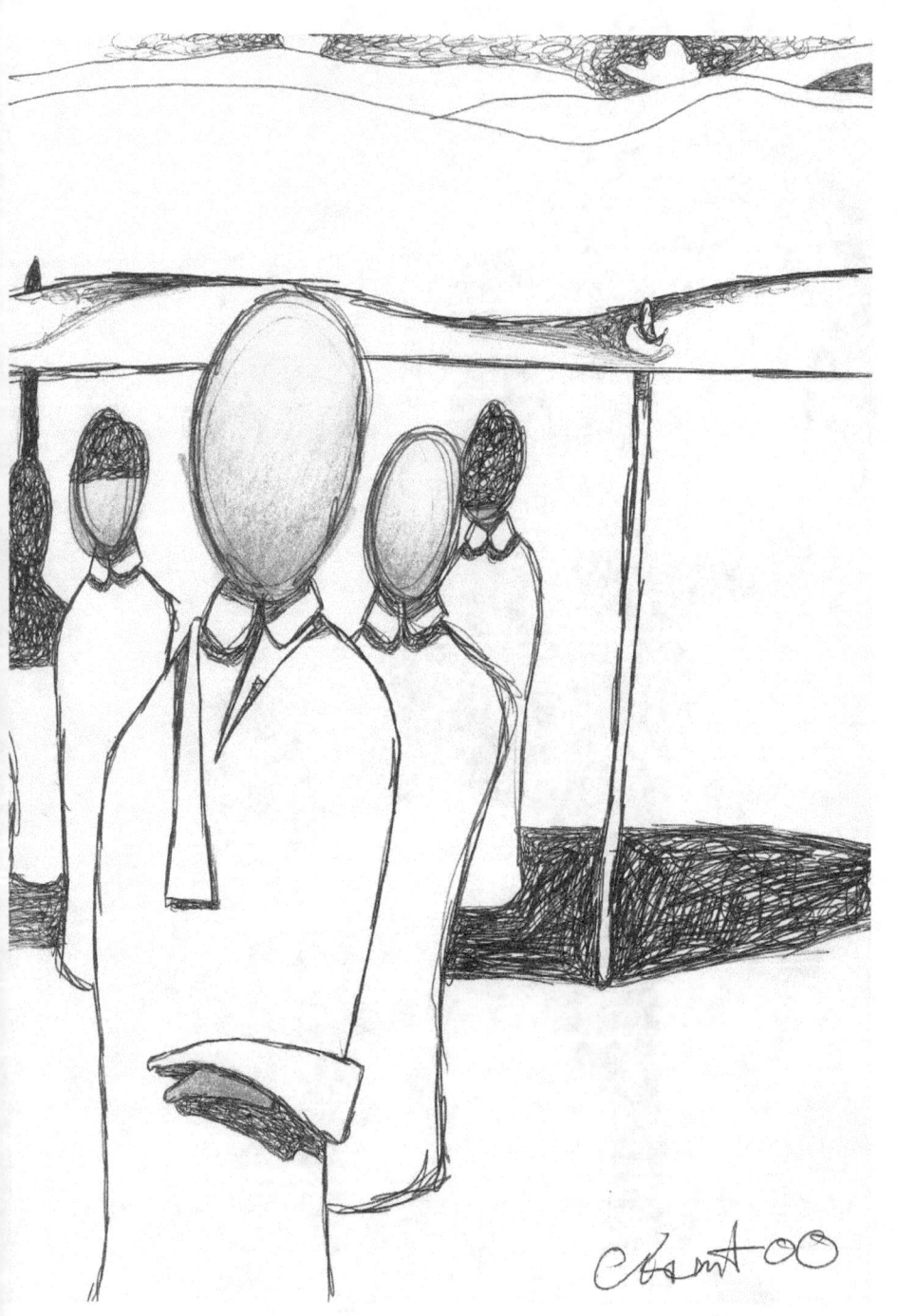

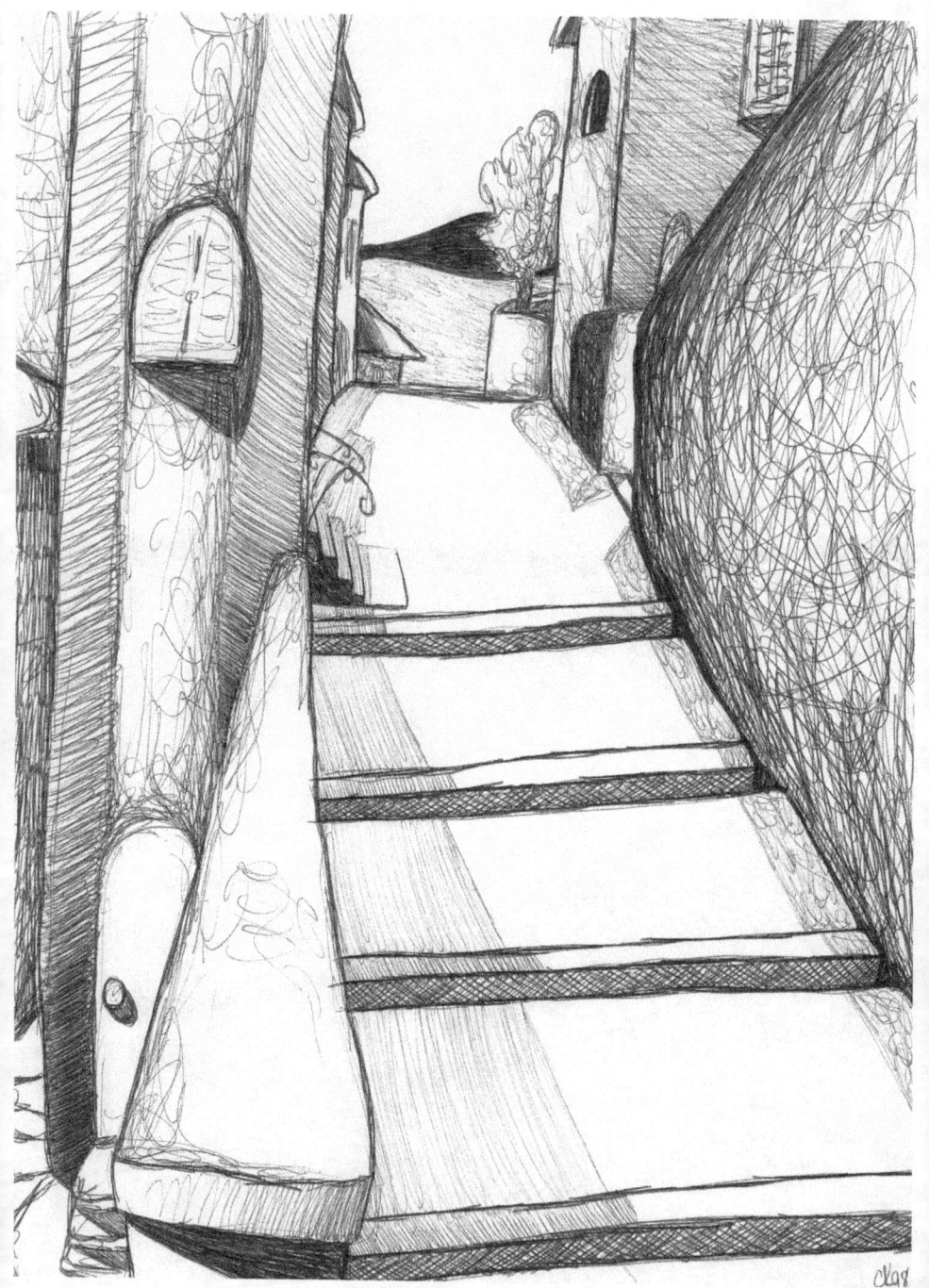

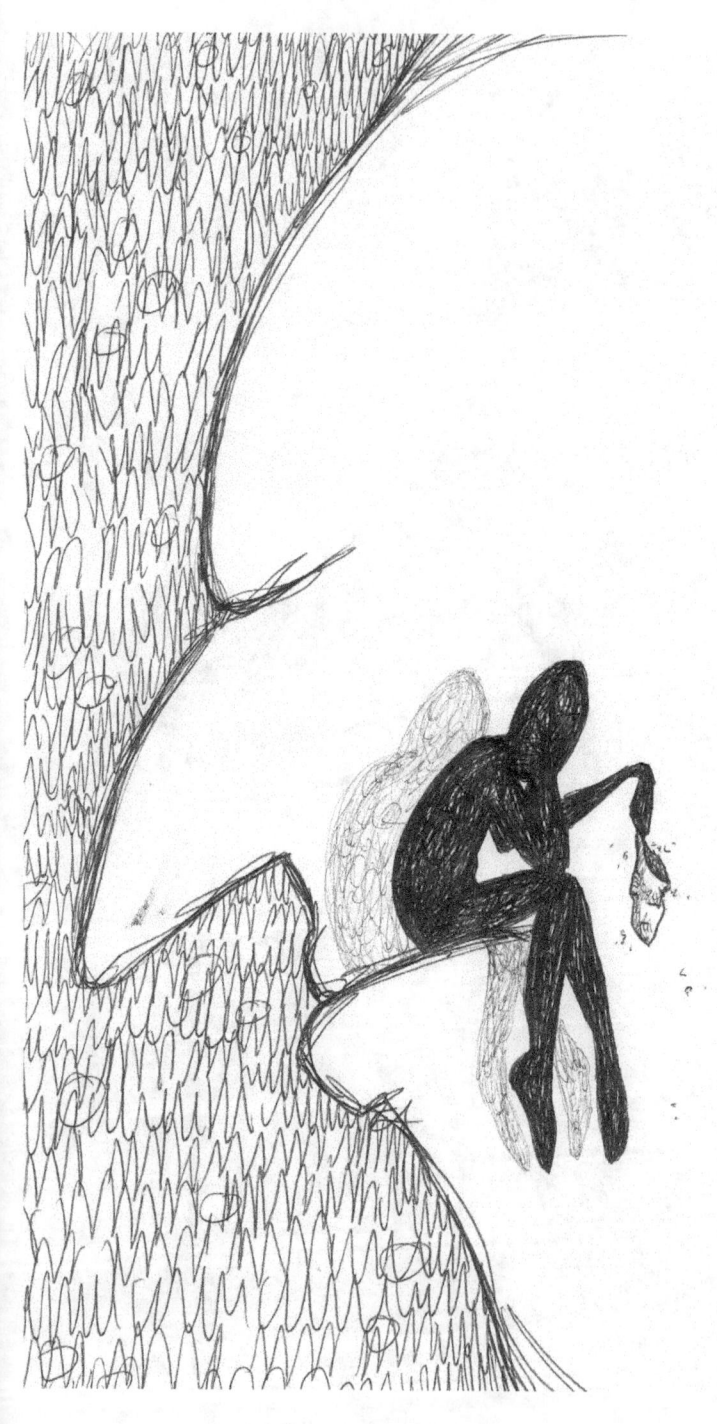

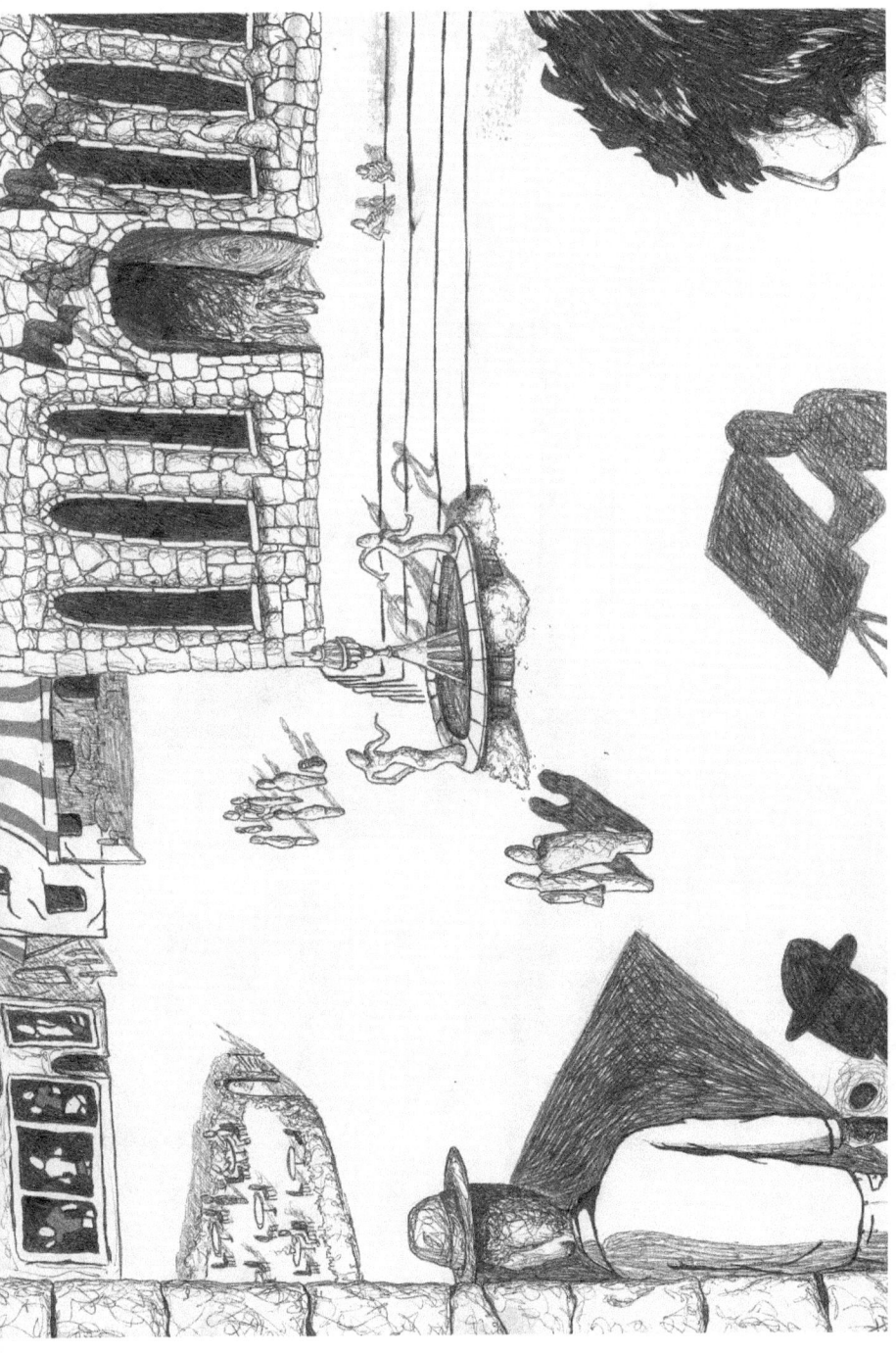

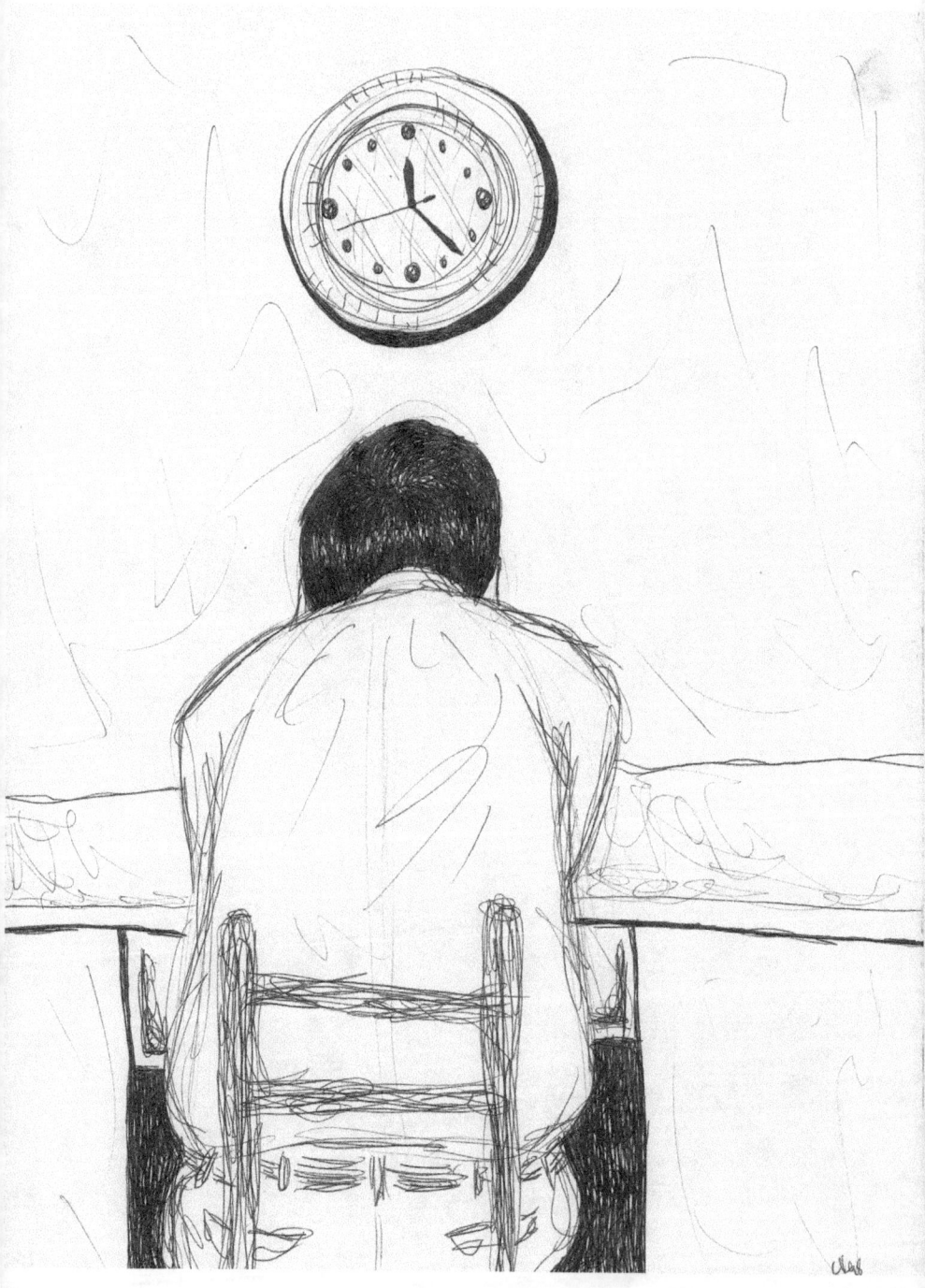

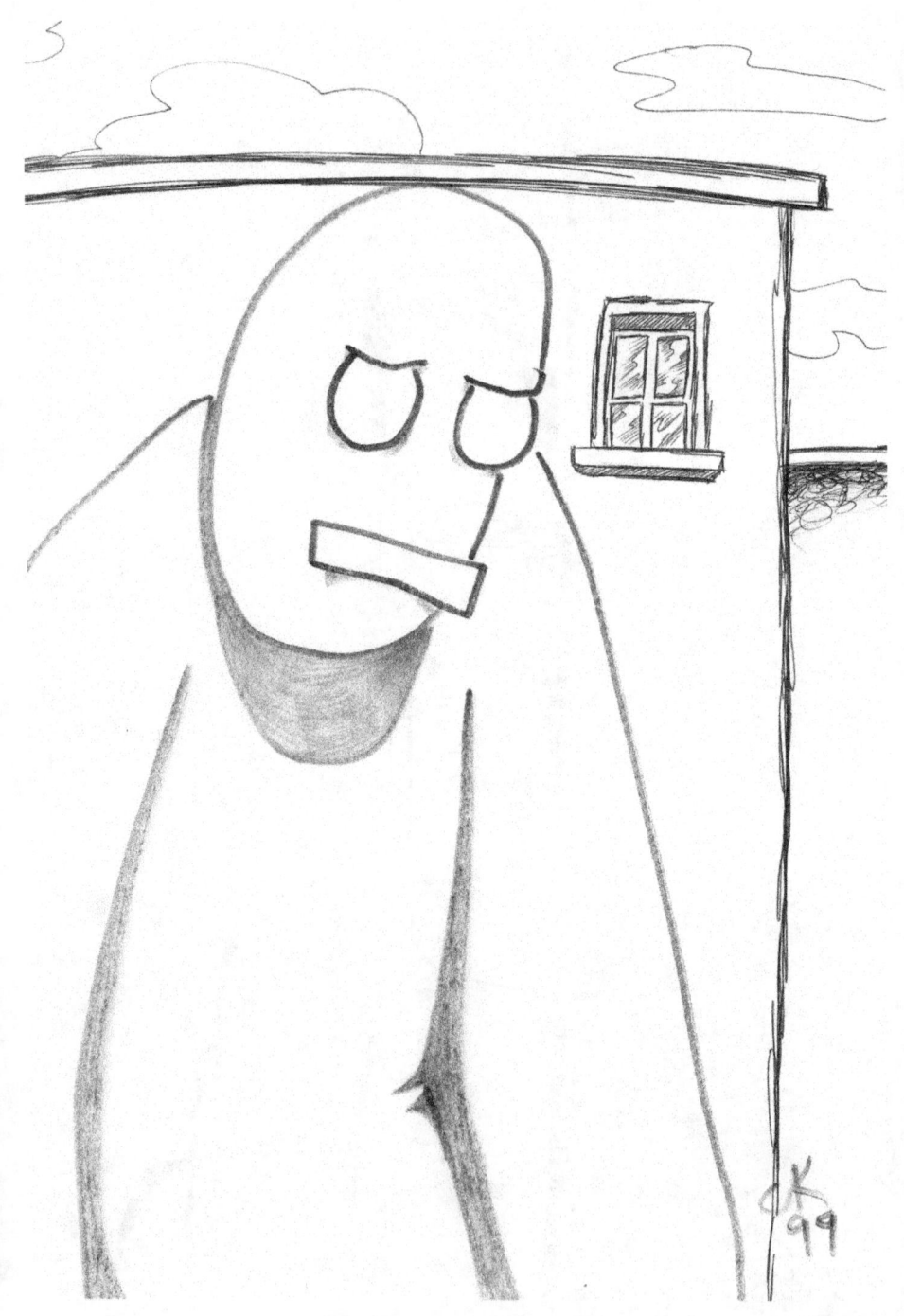

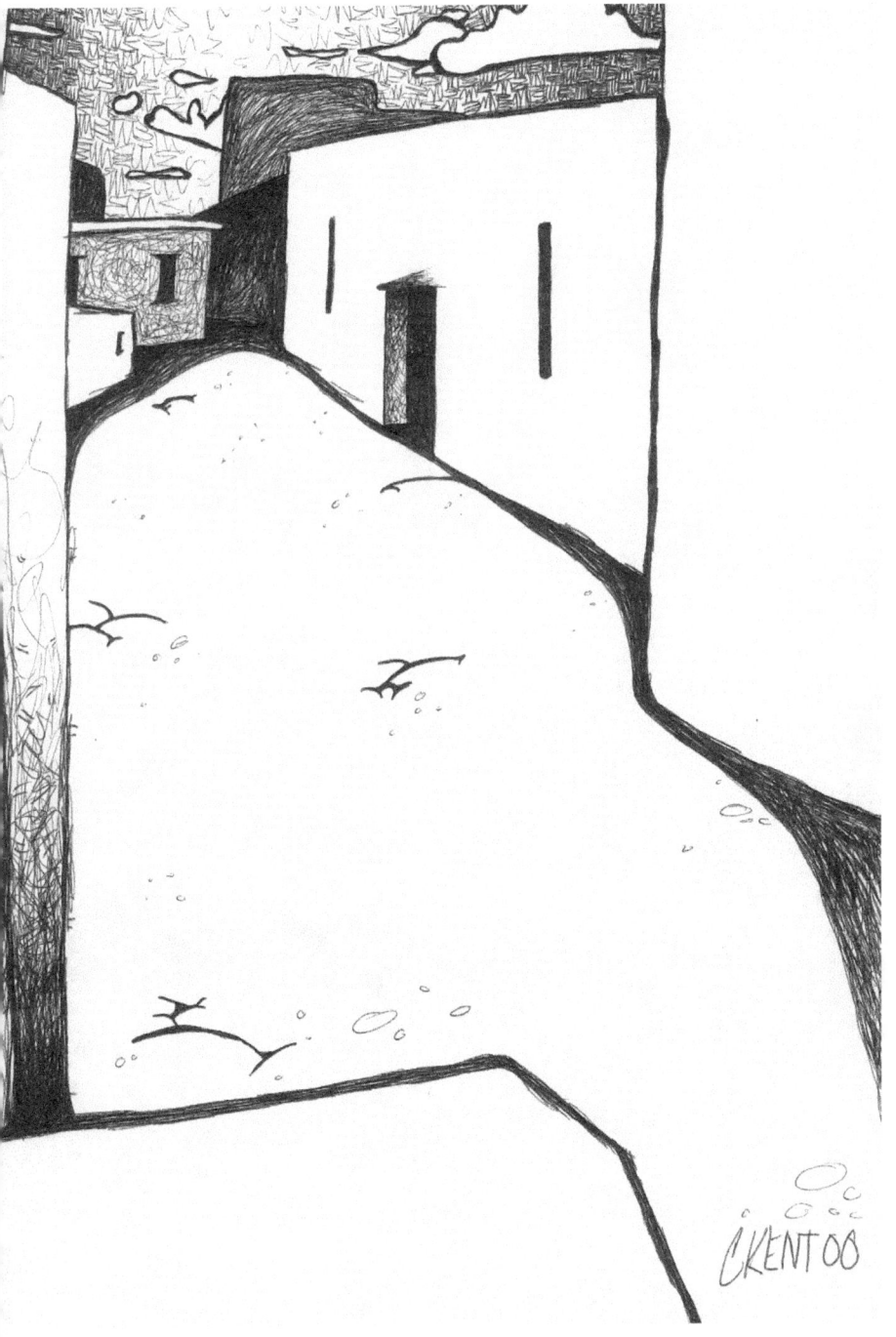

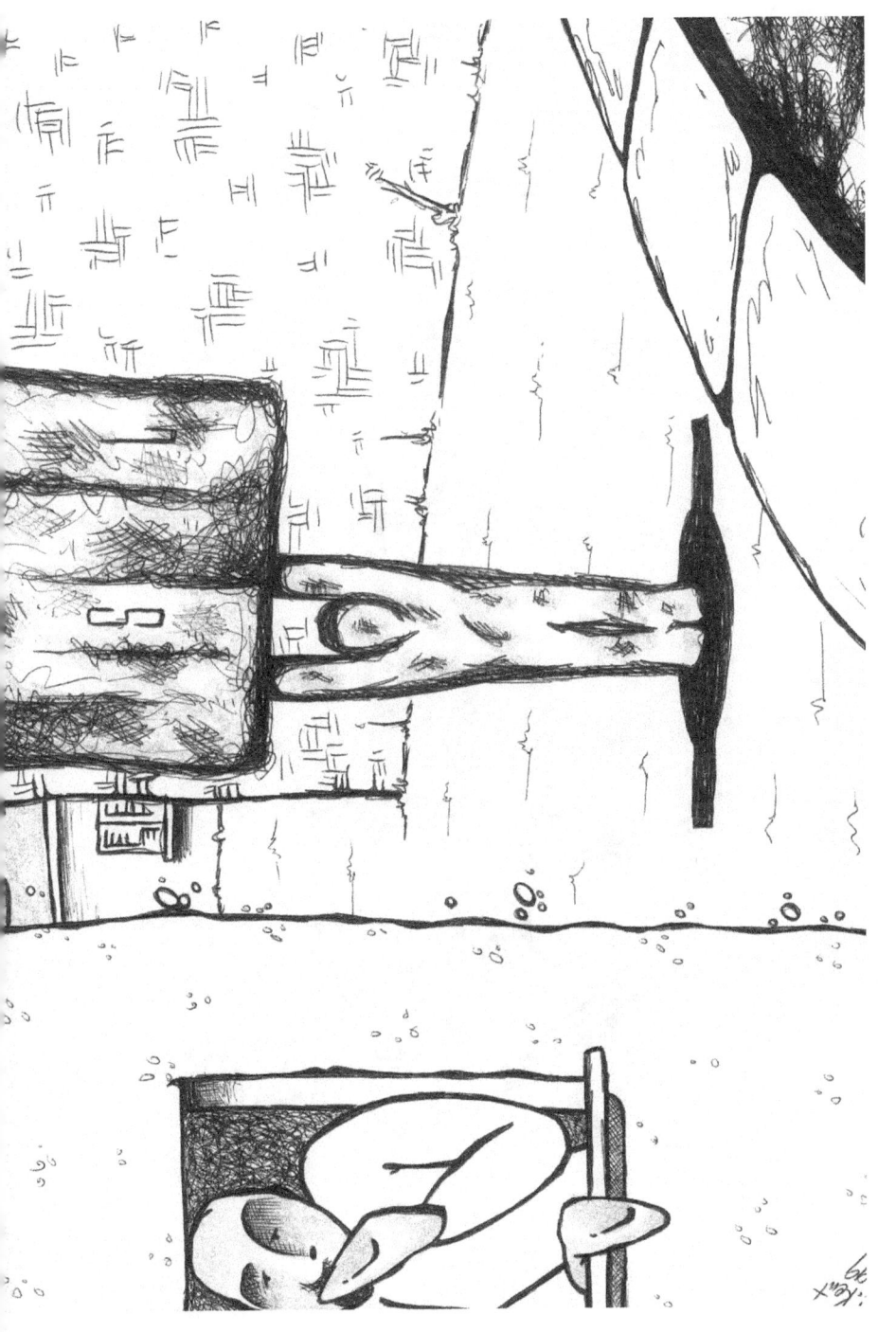

go to **CHRISKENCART.COM**